# Nathan Coley

—

National Galleries
of Scotland

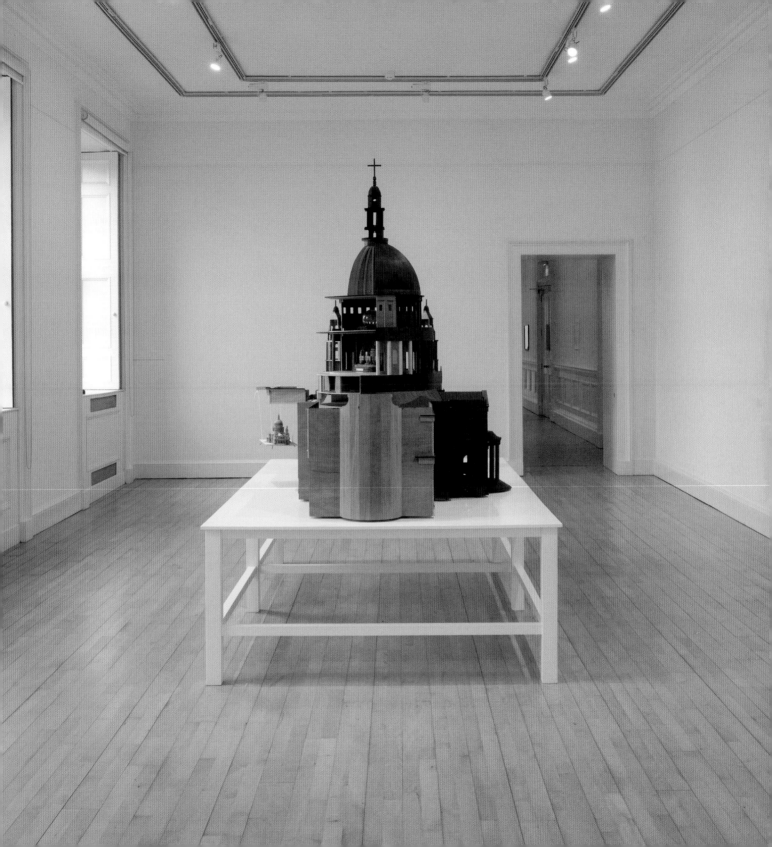

# Foreword

Nathan Coley's <u>The Lamp of Sacrifice, 286 Places of Worship, Edinburgh 2004</u> is one of the most iconic works held in the contemporary collection of the National Galleries of Scotland. This publication celebrates this landmark installation, and documents its display at the Scottish National Gallery of Modern Art as part of a solo presentation of Coley's work in <u>NOW</u>, a programme of exhibitions dedicated to showcasing the best of contemporary visual art. Alongside <u>The Lamp of Sacrifice</u>, the display of Coley's work features two further sculptural works by the artist: <u>Paul</u>, 2015 and <u>Tate Modern on Fire</u>, 2017, both being shown in Scotland for the first time.

In bringing these three major works by Coley together, the exhibition highlights fundamental questions about faith, power and architecture that have concerned the artist over many years. Coley is interested in how the built environment informs and influences the social structures in which we live – how buildings in the world become imbued with symbolic meaning, or take on particular institutional or social significance. Drawing on the real and the ready-made, his works pose questions about belief and what it means to each of us. Coley's work also has a strong physical presence, and the three pieces exhibited in <u>NOW</u> demonstrate the artist's approach to the hand-made and to the labour involved in creativity.

In light of the detailed restoration of <u>The Lamp of Sacrifice</u>, following its damage by water in 2014, it is particularly timely to be considering Coley's work afresh. We are extremely grateful to author Ewan Morrison for agreeing to contribute to this catalogue, and for writing such a compelling, insightful and provocative text on Coley's work. Morrison's essay reflects the complexity and ambiguity of Coley's artistic practice, and opens up the landscapes of history, art history and politics which his work inhabits. Morrison also reminds us of the deeply personal responses that art can generate – and that when we encounter Coley's art, we each come to it on our own terms.

We warmly thank Ben Tufnell and Matt Watkins at Parafin, London for their generous help in making this book a reality, and in particular to Matt Watkins for his elegant design. We thank photographer Graeme Yule, for recording the exhibition so beautifully. At the Gallery, we would like to thank Cassia Pennington, Lorraine Maule, Emma Davey and our skilled art handling team, along with Lucy Askew and Julie-Ann Delaney, the curators of the exhibition. In addition, we thank Lucy Askew for editing this book. Finally, we are indebted to Nathan Coley – we not only thank him for his art, but are grateful for his close and generous collaboration in the making of both the exhibition and this publication.

Sir John Leighton
Director-General, National Galleries of Scotland

Simon Groom
Director, Scottish National Gallery of Modern Art

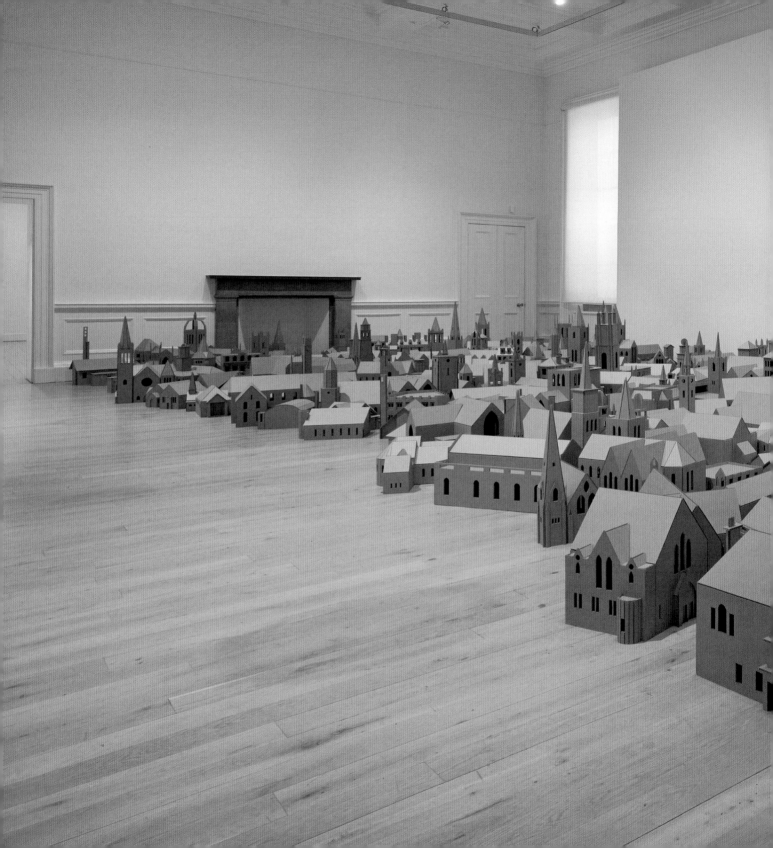

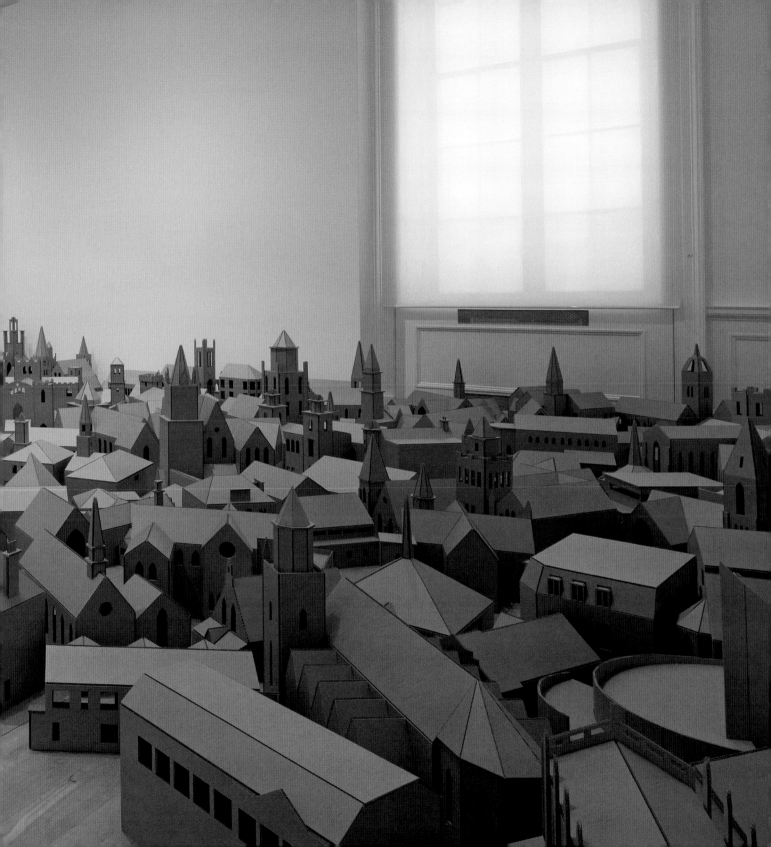

Previous pages:

The Lamp of Sacrifice, 286 Places of Worship,
Edinburgh 2004, 2004
286 cardboard models; 2 photocopied and
annotated pages from Yellow Pages
Cardboard models: dimensions variable;
pages, each: 42 × 29.5 cm
National Galleries of Scotland
A Fruitmarket Gallery / Bloomberg Commission:
purchased by National Galleries of Scotland with
funds from the Cecil and Mary Gibson Bequest 2004

Opposite:

Tate Modern on Fire, 2017
Painted plywood and mixed media
90 × 100 × 170 cm
Private collection, courtesy Parafin, London

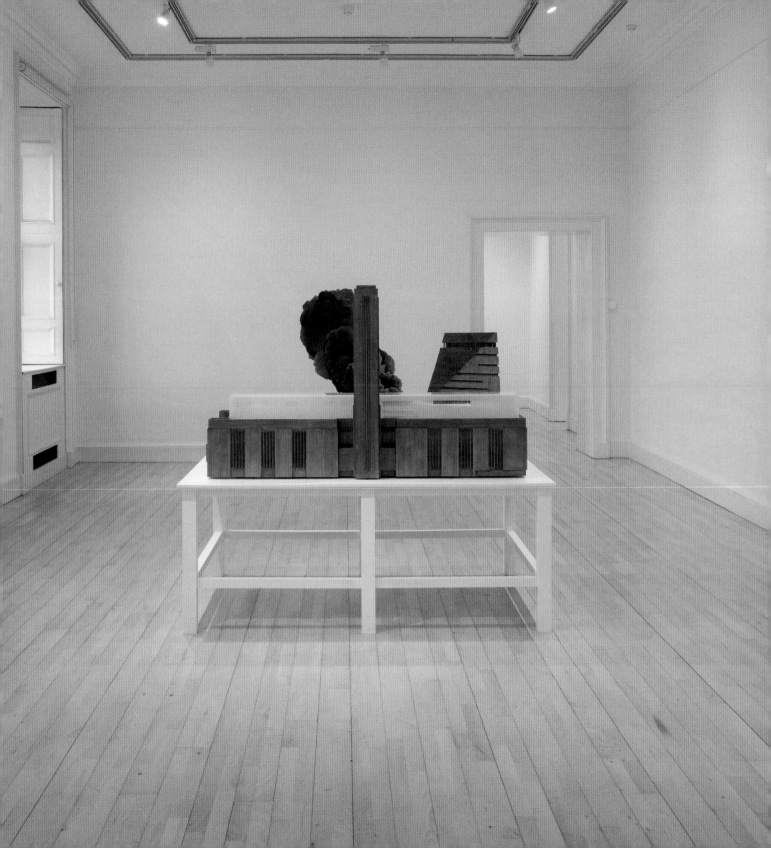

# Nathan Coley:
# Architectures of Belief

Ewan Morrison

The infant owns a doll's house and plays in a Wendy house, or makes a house from Lego or from sticks. She or he populates this world with little people, imaginary, home-made or mass-produced. Entire industries exist to manufacture miniature figures that will inhabit the child's mental projection. Palaeolithic and Neolithic dolls have been excavated, made of sticks and hair, showing that the child's need to construct models of reality is genetically hard wired.

The pre-teen makes a model building, car or aeroplane, and this is a test of concentration and of purposeful endeavour, but also a vessel for magical thinking. 'One day I will fly a plane.' Or, 'One day I will have a family.'

The student makes a model to develop skills and to discipline the self, to discover how the forms of the adult world fit together and to solidify the boundaries between self and others. To say, 'I made this. I own this.'

The graduate makes models of their designs, demonstrating their ambitions, talents and vision, inviting others to value and rate them.

The architect commissions the model to demonstrate to the client what the structure will look like, to safeguard against miscalculation and to attempt to secure the investments needed.

But the artist?

The artist who makes a model, post fact, after the likeness and to the scaled-down dimensions of the original – is he not perverse?

Is he not in some way inverting the chronology and hierarchy? Saying, 'You planners of society and its structures, look, you are driven by the same desires as children.'

There is something unsettling in reconstructing an existing building in miniature. Crime scene investigation (CSI) teams reconstruct, in detail, the sequence of events from a disaster, by gathering the fragments and creating a detailed scale model, whether of a plane, house or tower – to detect the point of entry, of structural weakness, the blind spot that facilitated the destruction. They make models of places that have been destroyed.

And there are those others who make scale models of buildings; those who are searching for such weaknesses.

And in their way, they, like children, bend down and stare in, and move imaginary figures around, saying, 'He will go to here and then this will happen, and then through this door, and then from that window.'

And these people are called terrorists.

And each of these, from young learner to destroyer, is, in their own way, involved in the same activity. The model is the house of the imagined event, in which people place their faith in future outcomes.

And the artist is both infant and CSI team, both architect and saboteur. When he makes models after the fact, is he not asking us to look seriously at the structures in which so many lives have placed their faith and populated with their imaginary selves? Is he not asking us to gaze at the empty shells left when the faith that built such structures has vanished?

Given that we still reside in the domain of Immanuel Kant's imperatives and his demand that a respectful distance be maintained between the viewer and the object of aesthetic contemplation, when we approach Nathan Coley's work we often find that we have to restrain ourselves.[1] There is a desire, when encountering his scaled-down versions of reality, to bend down to child height, to try to peer inside, to see what is hidden behind the façade. This participatory curiosity activates the part of the brain that is to do with exploring, testing and creating 'maps of meaning'.[2]

But this process is not childish. In many ways, it is an ability that we, in an over-managed world, have lost sight of; a skill of the imagination that we have let atrophy.

There is something else to do with childhood perception in Coley's work: the unheimlich or uncanny, which has been found to lurk within our perception of life-like but inanimate objects, from puppets, masks and dolls to prosthetic limbs, dioramas, models and waxworks.[3] Models on the scale of childhood haunt us with the uncanny sense that things, which we rationally know should not possess life, are somehow alive: the forces that once animated a puppet, the supernatural beliefs that once built a cathedral. Coley's work haunts with the sense that that which modern man has spent over a century trying to banish, still persists.

Coley's artwork Paul, based upon St Paul's Cathedral, forces us to ask, 'How could we have once believed, so strongly, that we built such structures?' Or even, 'How could we have believed in such things that possessed such power over people?'

Upon reflection, we might also ask ourselves what we could possibly believe in today that would create such awe-inspiring architecture, if faith is now separated altogether from form. Are the forms we construct today merely imitations and parodies of the powerful unity of faith and form that was once widely understood?

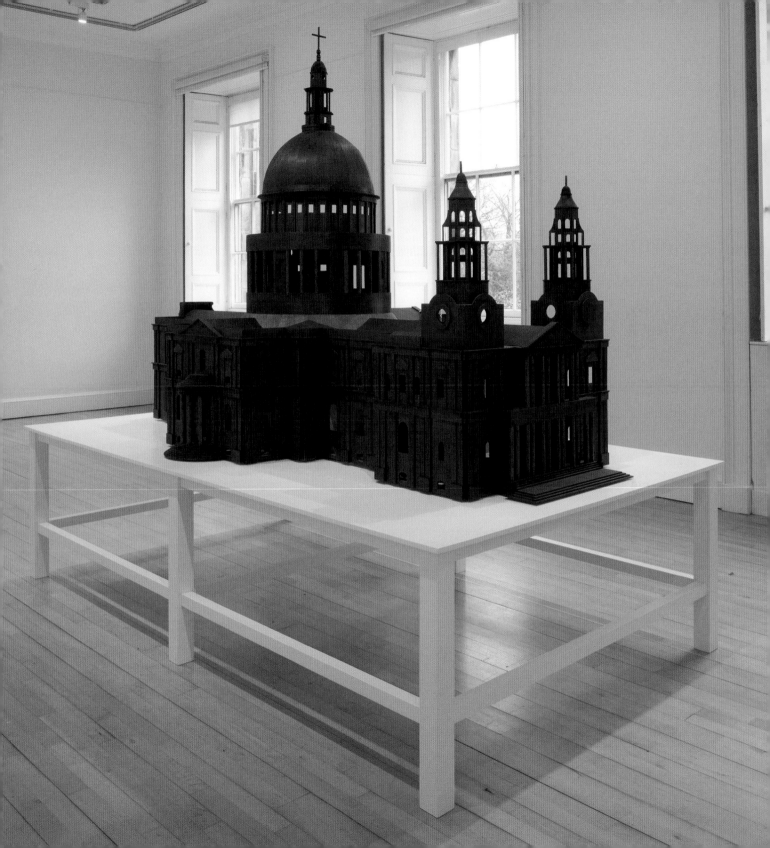

St Paul's Cathedral had already been burned to the ground four times from its foundation in AD 604 to the time after the Great Fire of London when Sir Christopher Wren was commissioned to rebuild it, one thousand years later.

Its struggle with destruction through fire was dramatised in December 1940, during the Second Great Fire of London – the Blitz – when Sir Winston Churchill made a call to demand that all firefighting resources be directed toward St Paul's: 'The Cathedral must be saved . . . damage to the fabric would sap the morale of the country.'[4]

The idea of a cathedral that gave an entire nation unity is ironic given the conflict Wren's designs created. The final design was only reached after four preceding versions and much disagreement: the Scheme or First Model was rejected; then the Greek Design; then the Great Design with its vast dome; and finally, the Italianate Great Model was rejected. The Warrant Design, so-called because it received the royal seal of approval, was passed only with a greatly reduced dome and a style that mimicked the Gothic of English churches. Building began in 1675, but the design was redeveloped during construction over thirty years. Through this process, Wren was able to reintroduce the large dome inspired by St Peter's in Rome and an expansion of scale and decoration.

One may look at this through the eyes of the Postmodern and see in St Paul's a plurality of ideologies in conflict and compromise; one could see this building as a work of historical bricolage.[5] Such an interpretation would play down (to the point of erasure) the issues of faith, inspiration and genius that may lie within the structure. It would deny that the structure of St Paul's may be a masterful overlaying of maps of meaning that achieves unity of purpose and form.

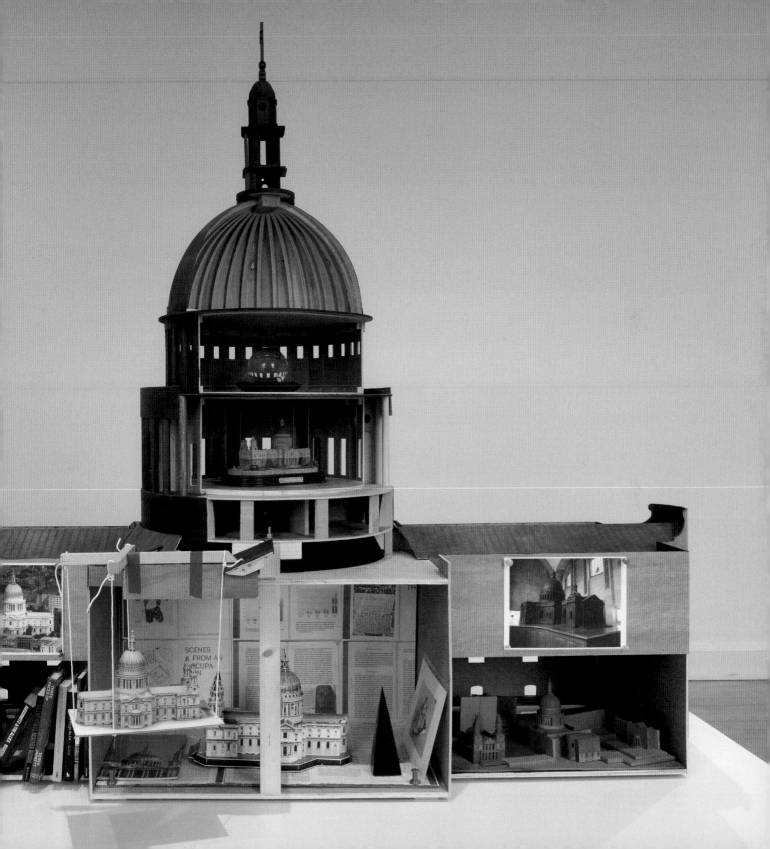

SCENES
A FROM AN
THE CUPA-
TION

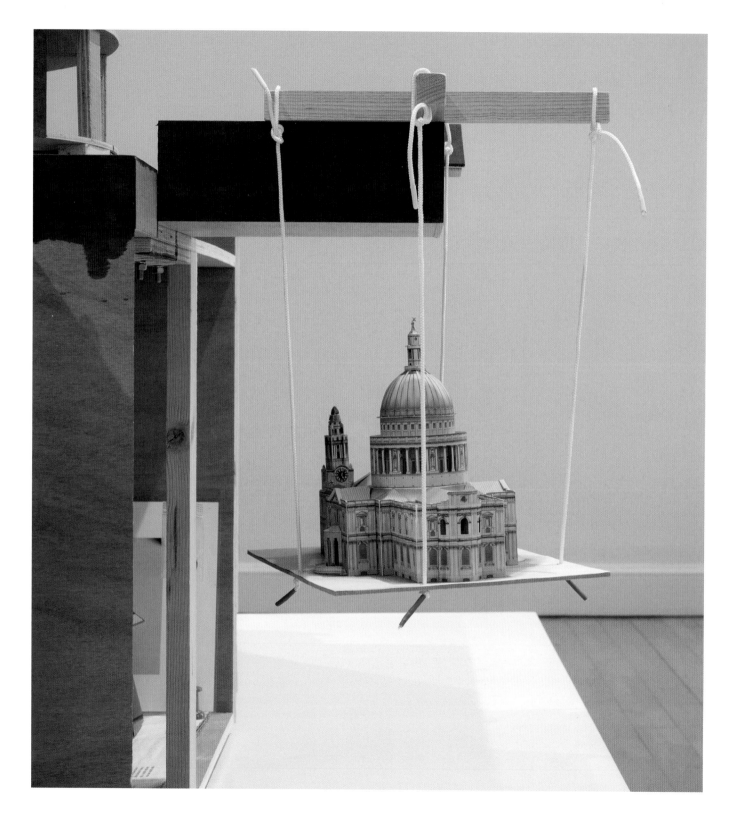

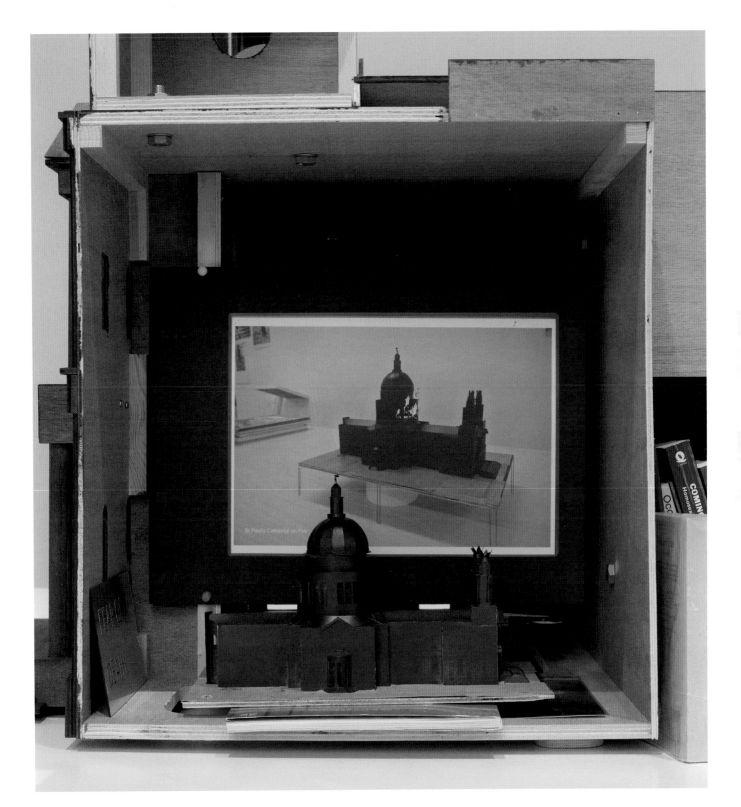

A proposition: to combat our postmodern fear of religious buildings, we might make a miniature model. We might say, 'Look, this is all religion amounts to these days.' The once vast and terrifying house of God is just three feet high. And the model itself might echo, ironically, the model that Wren made for his Great Design. And by moving, in our minds, around the model, we might bypass our fear of Christianity. Even so, with that little model we have to contend with the echo of the faith that built the original, and with the magnitude of the labours of those thousands long-dead. That faith is almost gone now, but its forms remain.

Ironically, Coley's Paul, with its miniature scale, accuses us of smallness.

FAITH AND IDENTITY:
CRISTIAN POLITICAL EXPERIENCE

AUSCHWITZ & THE ALLIES  MARTIN GILBERT

HAMISH

THE SILENT STATE  HEATHER BROOKE

WINDMILL

DEREK JARRETT

GEORGE PHILIP

THREE FACES OF

OPEN TO JUDGEMENT  ROWAN WILLIAMS

DLT

Black & Gay in the UK  edited by John R Gordon & Rikki Beadle-Blair

TEAM

WREN'S CITY OF LONDON CHURCHES  JOHN CHRISTOPHER

AMBERLEY

Doris Lessing  Briefing for a Descent into Hell

GRAFTON

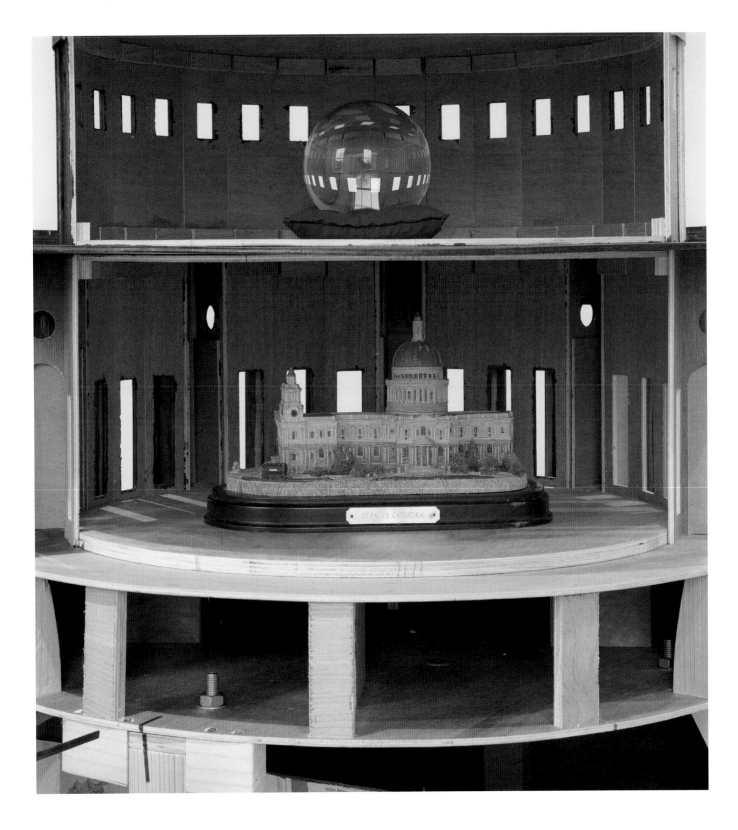

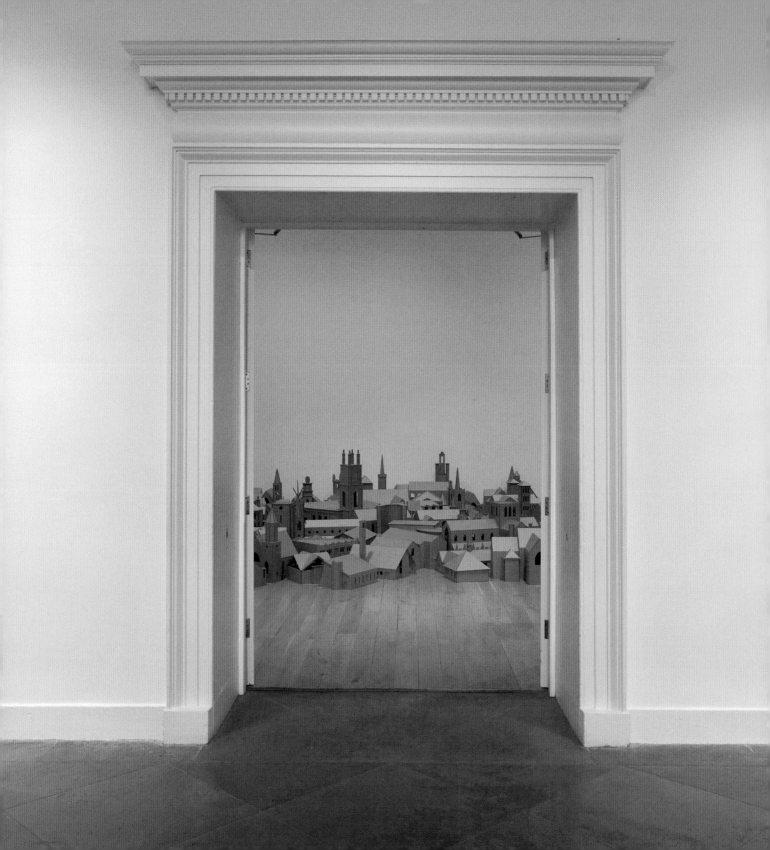

A man stands with his two children before the artwork. He sees them only at weekends and he is not a fan of public art galleries, but having his children in his flat upsets him, since his divorce. So, on Sundays like this, he has time to kill before he drives them back to their mother's home.

His youngest, the girl, breaks free from his hand and runs towards the cardboard buildings. He tells her, 'Don't touch!' She's leaning down, looking inside. She asks, 'Are there people, Dad?'

The boy tuts at her, 'Don't be stupid!'

'Be nice to your sister,' the man says.

He and the boy watch the girl running from one model to the next. She's shouting with glee, 'What's this one, Daddy?' 'What's this one?' She's in front of one that looks like a mosque, and then one that looks like a Roman Catholic church built in the 1950s. 'What's this one called, Daddy?'

'I don't know,' the man says, not too loud, so as not to draw attention.

'Go on, go and explore too,' he says to his son. But the boy stays frozen. 'What's wrong?' the father asks. He notices his son is staring hard at the buildings.

'I hate it.'

The man does not know why his son seems so afraid of these simple, cardboard forms that his daughter peers into as if they were doll's houses. The boy has barely been inside a church. At home, he obsessively makes Lego houses.

It comes to the man that he was married in a church, even though he didn't believe in God. His son has seen the wedding photos in the church. That was maybe it.

The boy aims a kick at one of the models, and the man grabs him just in time, yanking his arm. 'Why did you do that? Eh?' He's shouting (but not shouting). He doesn't want to make a scene. 'Don't touch the art! Bloody hell!' Now the boy is crying and the girl runs over and wants a hug.

He has an hour to kill before he drives the kids back to their mother. There is nowhere else to go and it's raining outside. So, he just stands there holding his two children firmly, making them behave themselves.

It comes to him that he can no longer recall why he and his wife divorced. It had seemed, somehow, the done thing. He stares at the little buildings and something sets him off. It's maybe how small they are and how it's like some reminder of how important places of worship once were. Look at them – so tiny his son could have crushed one of them.

Some feeling opens up in him.

'Can we go to the shop now, Daddy?' asks the girl, tugging at his hand.

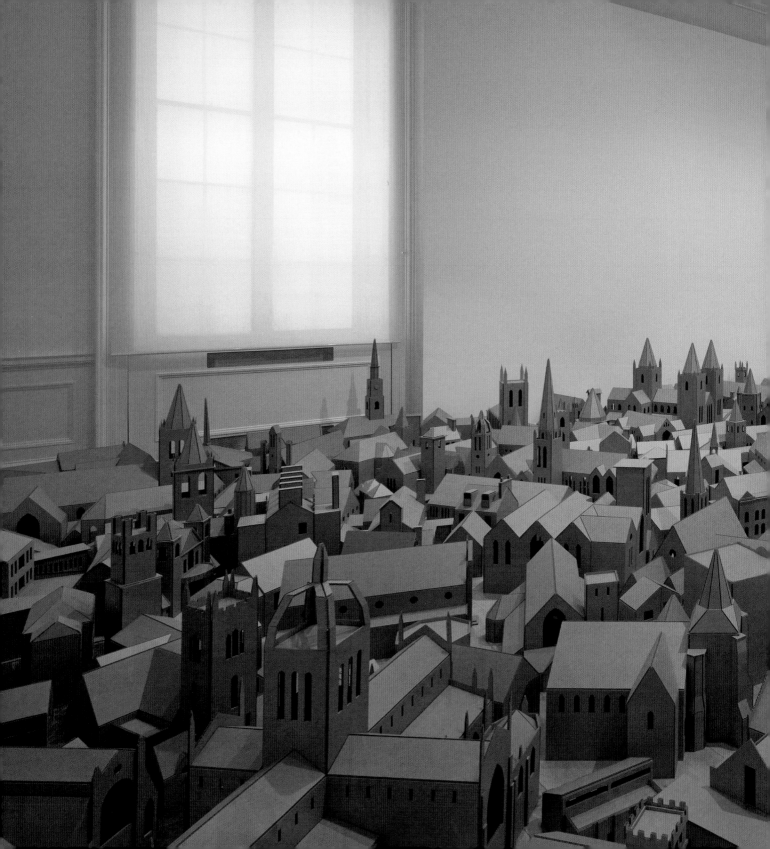

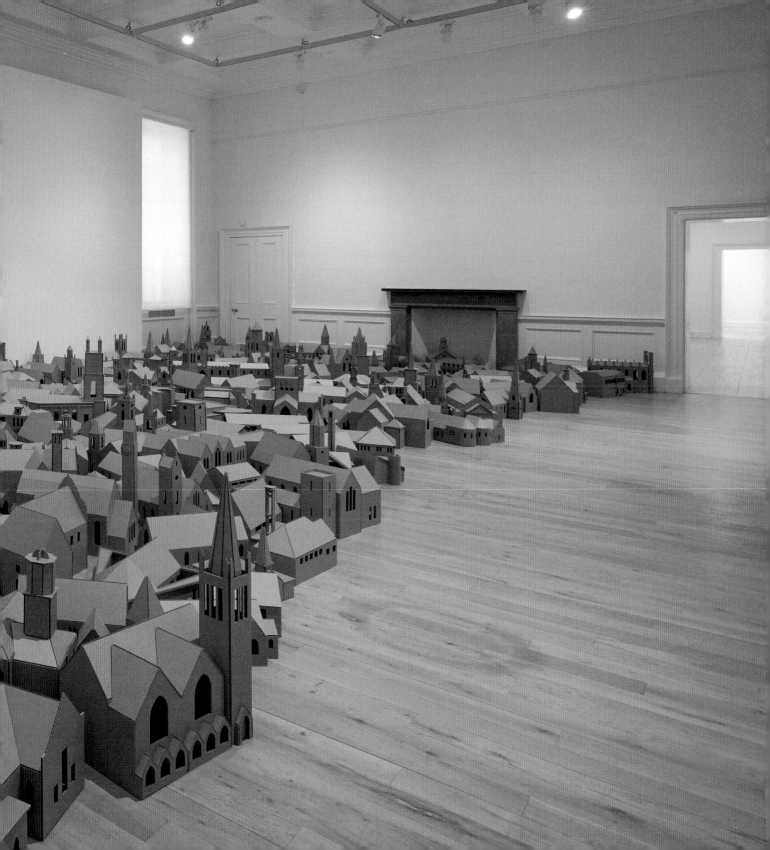

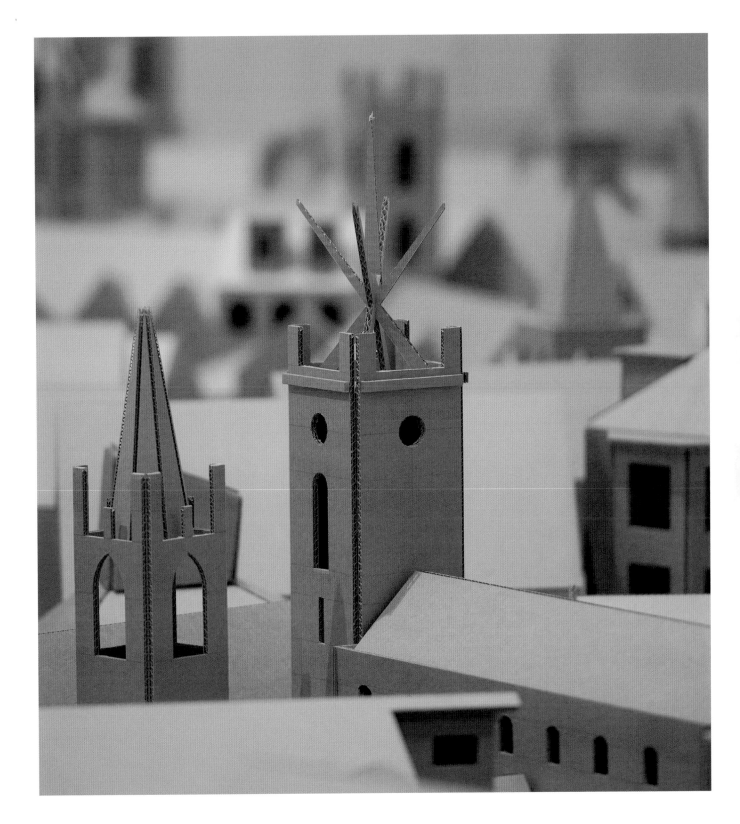

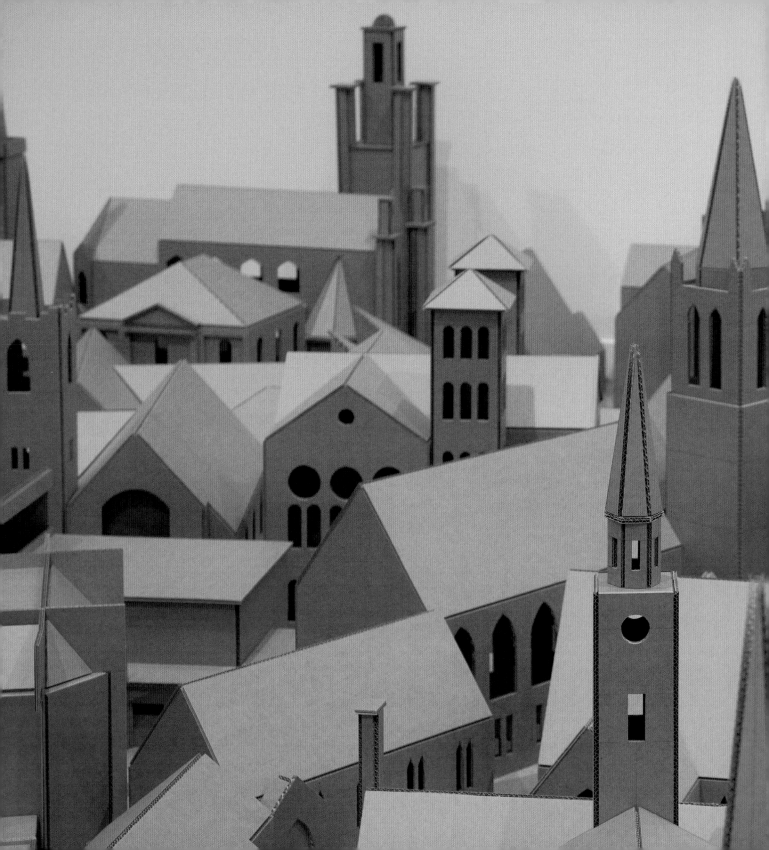

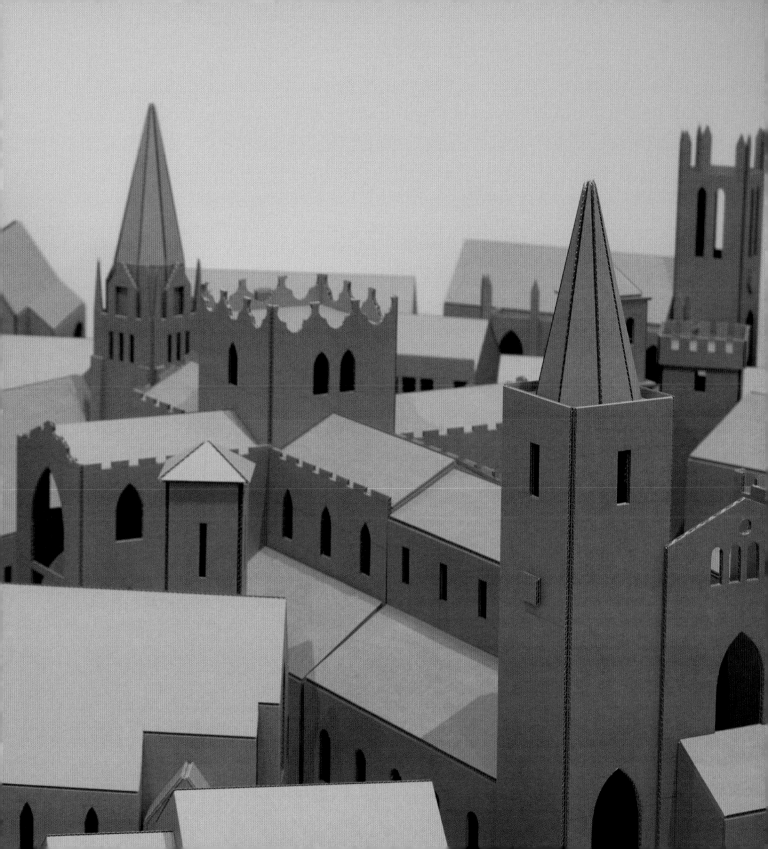

During the 1980s, a certain mode of communication came to surround artworks, which characterised itself as 'Postmodern discourse'.[6] This credo defined itself in opposition to the phase of Modernity that preceded it, and all of the language of Modernity had to be purged from within it. Modernist terminology included self-expression, mastery, creation, skill and other 'artefacts' such as 'the soul'. The modernist frame ended at the edge of the artwork. It did not include the wall, the building, the institution, society.

The Postmodern reframed the Modern. The frame that surrounded art moved back to encompass both the wall and the institution on which the gold-framed artwork once hung. The use of parenthesis to 'problematise' such concepts was a postmodern technique, as was quotation and 'appropriation'. The role of the artist changed accordingly. The frame shifted: the artist became a reframer, a kind of social enquirer. Art in many ways became a meta-discourse on art.

Instead of generating meaning through crafting materials or self-expression, the artist became involved in practices that were variously described as 'challenging social norms' or 'deconstructing stereotypes'. Art schools purged the old forms and taught the new postmodern method; departments were overturned, institutions were flooded with this language, and Modernity went up in flames.

There was a postmodern list of subject areas to deconstruct and these largely corresponded to the four pillars of society: the church, the family, law and the representation of truth. This battle with the status quo, through combatting the representations of reality and the institutions that protected them, was even ennobled within art speak, and seen as part of the project of progressivism. Artists were leading the way (once again) to destroy the structures of society that held us back, and that bound us to hierarchies of oppression; language itself was an enemy to be fought.

These were the clichés of art speak and the modus operandi of art creation within this period. A tightly sealed dogma based on certain beliefs, which would not admit themselves as beliefs because the exponents of these beliefs thought they existed in the frame beyond frames; a super-cognitive frame that could not be expanded beyond.

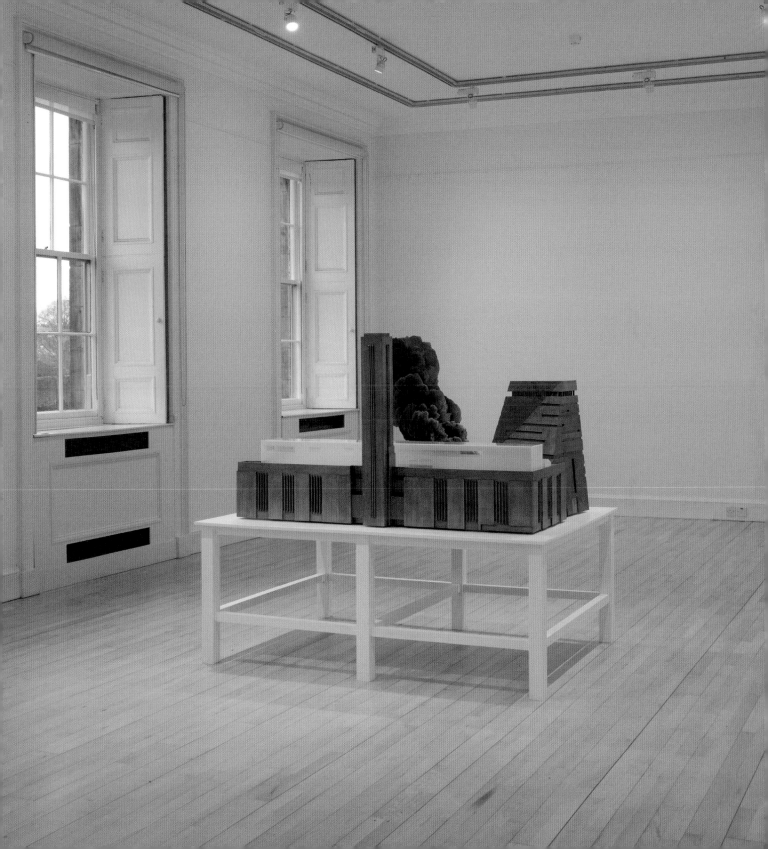

When we think of the Tate as a contemporary institution we think of its relentless avant-gardism. Within it, we witness the spectacle of the Postmodern decade after decade performing the death of art and its morbid resurrection. Carl Andre's bricks, Tracey Emin's bed, the Guerilla Girls, all destroying what came before to create something restlessly, temporarily new.

As early as 1996 there began a series of attempts to declare Postmodernism dead in the arts, architecture and philosophy, with each laying out a theory of what would come after. There was:

Turner's Post-Postmodernism.
Epstein's Trans-Postmodernism.
Kirby's Pseudo-Modernism or Digimodernism.
Eshelman's Performatism.
Bourriaud's Altermodern.
Vermeulen and van den Akker's Metamodernism.[7]

In retrospect, they were all diagnosing the same crisis of legitimation. All noted that the postmodern bricolage of recycled forms was reaching a point of stagnation, with nothing new or vibrant emerging, and nihilism filling the vacuum.

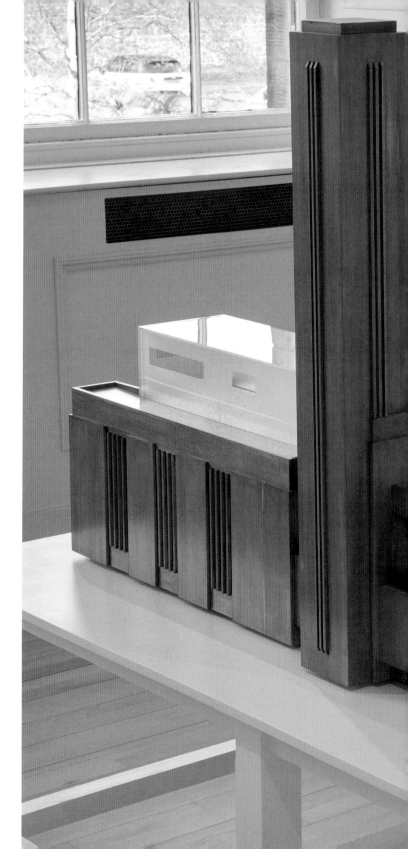

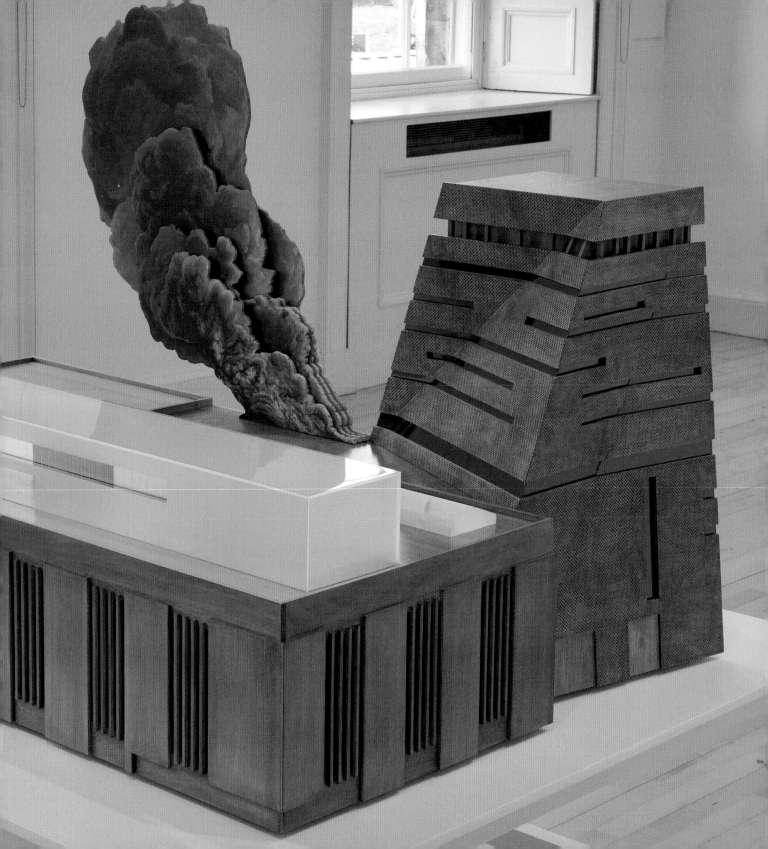

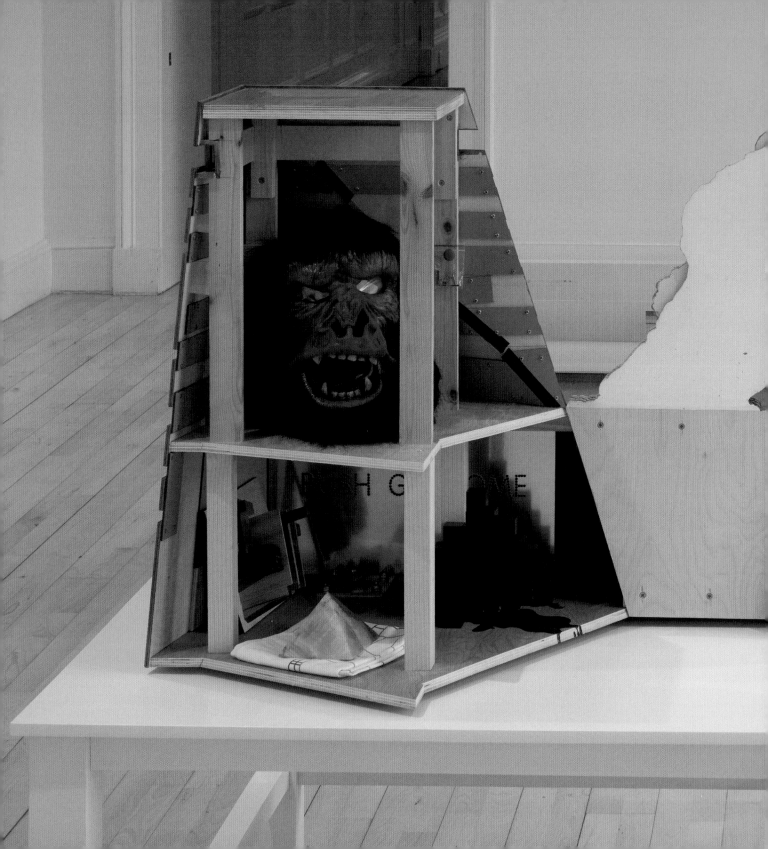

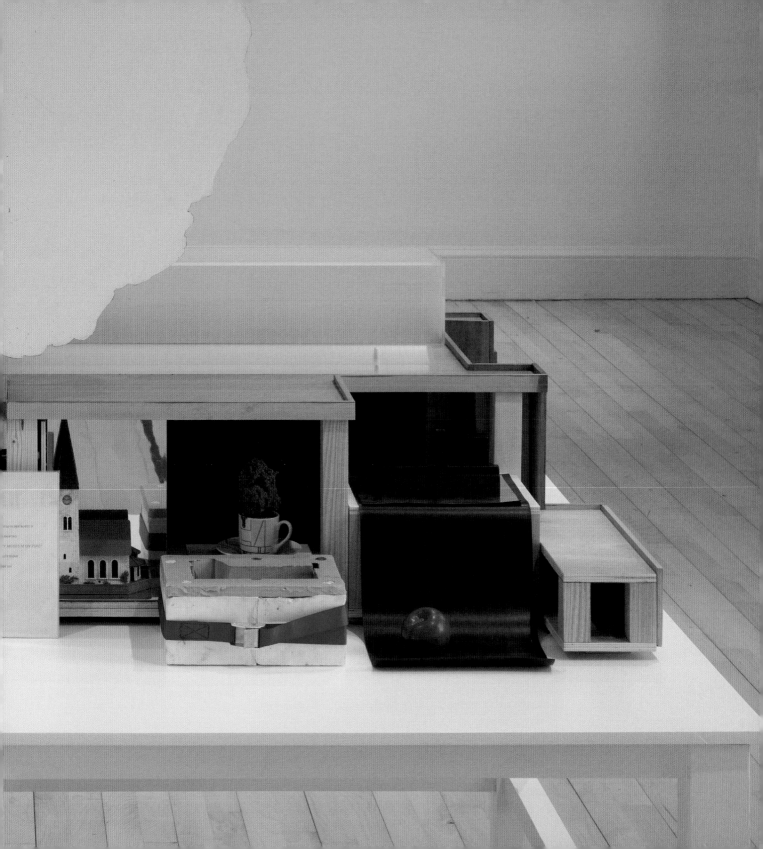

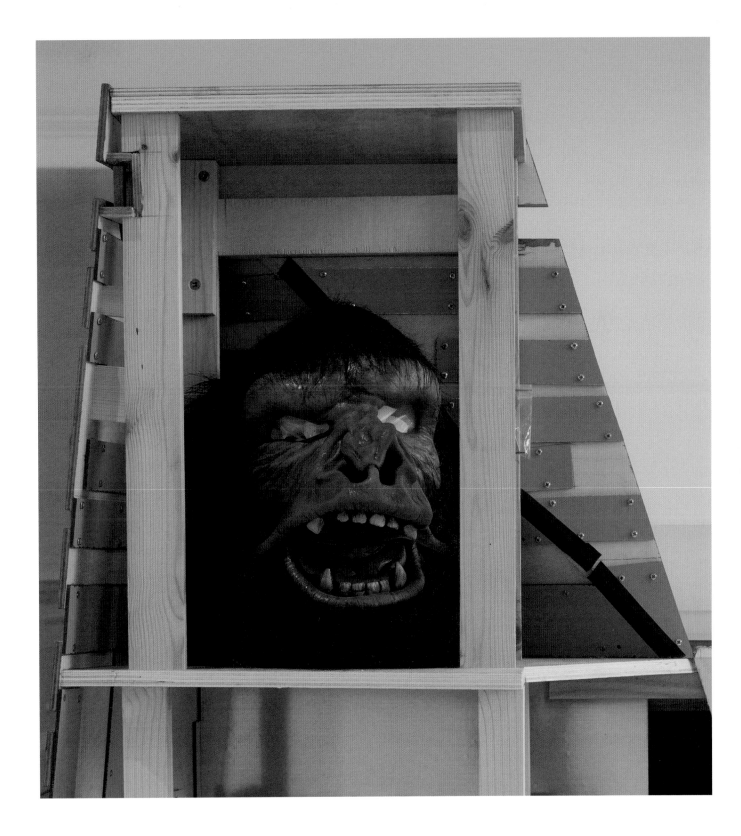

A LIST OF ART WHICH WOULD BE DESTROYED IF

ED RUSCHA'S PAINTING

"*LOS ANGELES COUNTY MUSEUM ON FIRE*"

BECAME REALITY TODAY

19 JANUARY 2011

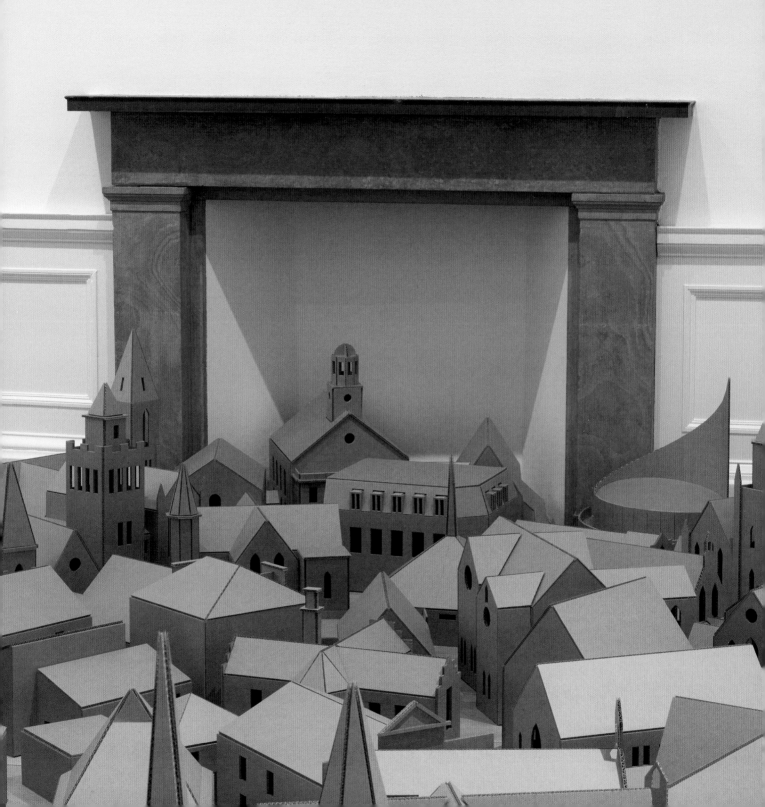

'Why did he do it?'

'What?'

'All those churches?'

'Don't know.'

'How many are there?'

'Two hundred or something.'

'Amazing. Why though?'

'I don't think he made them all himself, I think someone else did them, you know, like model-makers.'

'Pity.'

'How d'you mean?'

'Well, just thinking of a guy doing that, like all that, doing that all yourself.'

'Aye, would take you months.'

'No, a year at least, like one a day, a year, has to be.'

'Aye.'

'Do you think he's . . .?'

'What?'

'A Catholic?'

'No, there's mosques and all kinds in there. I saw the old kirk my gran used to go to, over there by the wall. She's not a Catholic.'

(laughter)

'Is he though, d'you think?'

'What?'

'Well, religious. Is this, like, religious art, like . . . Michelangelo?'

'No, I don't think so. Artists. No. They're all atheists, aren't they?'

'Right enough. Most likely.'

'He's probably just making some comment like . . .'

'Like what?'

'Well, like . . . saying religion's dead.'

'Crap.'

'That's the kind of stuff artists say all the time.'

'No. No. Look at it, for God's sake, no way.'

'What then?'

'Well, not that.'

'Well, what then?'

'Never mind.'

'Tell me. What is it? D'you think it's about death, 'cos it sort of is too.'

'Gives me the creeps.'

'Me too, but what d'you think? Go on, no-one's about. Quick. D'you think it's saying we're all going to die and, you know, even churches and that. And they're just throw away, like cardboard, and that's dead sad because, like, who's going to remember us.'

(silence)

'No, not really.'

'Never mind then.'

'Maybe we should read the sign.'

'What sign?'

'The instructions on the wall.'

'No, never mind. It'll just spoil it.'

'Alright. You coming then?'

'No, on you go. Just leave me here for a bit, eh? I'll be out in a minute.'

The Postmodern has died and we live in denial. Globalisation is falling apart, and with it the cognitive map that validated postmodernist pluralism. Multiculturalism too is struggling to regain its legitimacy, discredited by an excess of its own methods and by an incompatibility between historical outcomes and the ahistorical utopianism at its source.

What has unseated the Postmodern, the Modern and the ideal of the Global is not any debate within the arts, architecture or philosophy, but is, unexpectedly, a set of discoveries about the workings of the human mind.

As psychologist Jordan B. Peterson has said, we have within our species something like an 'Architecture of Belief' and we acquire knowledge of experience through the placing of faith in order that we might overcome the fear of that which we do not yet know.[8]

What comes after the Postmodern is that which the Modern tried to excise and destroy. It is an art that acknowledges faith has not withered away, as Modernity promised, but that it may even be an inherent structure in the way we cognitively map.

There are artists, few in number, who straddle the Postmodern and the new period and they do this by asking challenging questions about human nature. They do this by asking us to look at the materials through which man explores the foundational need for belief.

Coley's art confronts us with objects that possess historical memories. It can make us feel uncomfortable, in a way that is not disconnected from the habit we have of turning away from footage of religious terrorist atrocities. In our contemporary globalist world view, there is no place for oppressive superstitious phenomena like faith. We'd rather wish religion away and in doing so, ironically, we are guilty of the same magical thinking that underlies religion.

What if the project of Globalisation, of a universal mankind, was also just a form of faith? This could only be an offensive proposition for the modern, humanistic, secular and scientific mind. What if the globalised, multicultural, liberal, tolerant subject turned out to be a fantastical invention of mere intentionality, with no historical evidence to substantiate its merits? What if, like a faith, it is a project that believers inflict upon non-believers? What if secularism and its political manifestations are an evangelising creed, which has created its places of worship within public artworks, inter-governmental organisations, quangos, institutions dedicated to social engineering, state-funded media, and art galleries and museums? What if the institutions of the secular modern state, created by the atheist progressive subject, are as dependent upon faith as any religion, and that progress, diversity and equality (or Liberty, Equality and Fraternity) are just other names for the Holy Trinity?

In this light, one could look at Tate Modern and see it as a cathedral, one that elevates man to the status of the God that institutions like it destroyed.

In the context of the potential collapse of the globalist project and the possible implosion of the European Union, Coley's artworks ask such portentous questions. His concern with place and faith resonates with the zeitgeist statement made after the announcement of the decision of the British electorate, by referendum,

to quit the EU: 'If you believe you're a citizen of the world, you're a citizen of nowhere.'[9]

Citizens of nowhere inhabit the nowhere land of universalism from which all superstition and local belief has been erased. But this is not a place that anyone has ever seen. It is an ideal that we have been living within. There is no 'Place Beyond Belief'.[10]

Imagine a place where the dispossessed citizens of nowhere congregate to contemplate the ruins of their ideals. A place where they might find echoes of past political gestures, objects from demonstrations, trinkets from a time that once granted them status.

This could be the Tate.

And is it not – along with other institutions like it – now in danger of becoming as much a shell as St Paul's? The globalist project enshrined in the vision of a progressive universal humanity may be falling apart; such buildings may slowly empty of the faith that created them. If so, then those who would wish to destroy such a symbol may construct a map or a model, to find its entry points, its weaknesses.

Consider the possibility of Tate Modern on Fire.

The picture of the human brain we had imagined for the last century was wrong; it is neither a machine, nor a blank slate. There is genetic hardwiring that we cannot reprogramme. There are elements of the brain that live in a state of primal hyper-alertness and fear of unknown experience. This dynamic organism is involved in constant processes of sampling experiences: testing, comparing, filing under categories of similarities, differences and dangers, and creating maps of meaning.

We are endlessly categorising. We use stories and analogies, and these are not add-ons to understanding but the material of cognition. The child's fear of the monster is universal and is a tangible metaphor for the fear of the unknown. The hero's narrative of fighting the monster is a metaphor for the experiential process of conquering that which we do not understand or which we fear.

It transpires that we have little direct knowledge of the world beyond the cognitive maps we use, and that many of these maps have been passed down to us from archaic culture.

What has this to do with art?

Firstly, it proves that categories offered by traditional myths and religious systems might play a crucial role in making sense of the world, in providing us with roles, guides and archetypes. People from different cultures and eras have formulated myths and stories with similar structures. We don't need to take them literally to find value in the maps of meaning provided by the common tale of the hero's journey of self-sacrifice, devotion and transcendence.

This understanding highlights the importance of art that asks the awkward question of why religion persists; art that stands on the place where our maps of experience run out and where we are ignorant of what lies on the other side. The place where we step out of the cognitive map and realise, in horror, that that was all it was.

In Peterson's theory – there is no place beyond belief. We travel and we hit the unknown, we retreat in fear, but then we return to it again and again. We confront the unknown, we map it, we believe the map, we reduce it to a model in our minds, and with this knowledge we face the unknown again, and we conquer it, and so on. The story of the 'ever-resurrecting saviour', common to most religions, is a symbolic manifestation of this self-learning brain. The saviour dies and is resurrected, dies and comes again, and this is the story, in allegorical form, of our brain mapping the world and failing, trying, mapping and conquering fear.[11]

According to Peterson, voluntary failure to engage in such exploration produces a rigid way of thinking and being. Instead of constantly making new maps, myths and models, we become frozen and demand that reality must conform to the one map that we have decided is final. Such a way leads to an ideologically rigid, totalitarian character, and to the suppression of the threatening unknown that others represent. By the time that Postmodernism ossified into Political Correctness, separating all words and images into those that were 'problematic' or not, Postmodernism had become a rigid thought-system. You learned the correct jargon and you made politically correct art accordingly. You shunned, and even banned, that which did not fit the correct map.

Art, then, that takes us to the edge of things we fear, things which our culture has told us should not exist,

and which leads us through the cognitive processes of mental mapping – asking us to compare the model and the reality, the map and the terrain – such art protects us from becoming rigid. It protects us against the tendency to dogmatism and authoritarianism. Such art leads us to see that all cultural heritage is of value and that there are parallels between the myths of different cultures.

Rather than deconstructing myths, art can lead us to an understanding that, for example, Osiris, Ganesha, Lemminkäinen, Christ, Quetzalcoatl, Krishna and Attis were all faces of the resurrection myth; all symbolic of the brain that is ever adapting and remapping the daily cycles of life and death, stimulus and reaction, defeat and victory. Such myths serve as the mediators between the core and constituent elements of experience. A new kind of art is emerging from the self-made ruins of the Postmodern. This art has affinities with the sciences of evolutionary psychology, cognitive science, behavioural psychology and with anthropological investigations into comparative myth. This practice places human nature back within the frame, not to problematise and deconstruct it, but to make a genuine enquiry into it. This art does not deconstruct myths, but instead understands our dependence upon myth-making.

Accepting that art beyond the Postmodern can explore the great forbidden territories of Modernity and Postmodernity, brings art to some unsettling propositions.

Human nature cannot be willed away.

Placing belief in the unknown is a natural function of learning.

We grope towards something that has an internal unity that we ourselves cannot achieve, and some of us call this thing 'beauty'.

And those of us who don't experience this unity through art, look for it in something we call God. And the role of art was for the greatest part of its history intimately connected with worship.

All of this may make the twenty-first-century mind feel very uncomfortable. We might try to turn our backs on it. We may dismiss an artist who comes back again and again to remind us that something called faith is the functioning system of half the population of the world and that this phenomenon is pushing at the perimeters of our 'safe' world.

We want faith to go away, but it won't because it is the hardwired mental process. Coley is acutely aware that we are all grasping for meaning and purpose. His art emerged from the framework of the Postmodern but confounds this model and extends beyond it; it tells us that our maps may now be wrong, that we have been guilty of hubris, that we may have banished something we needed. His art tells us something we might not want to hear: that, in spite of our best intentions and efforts, we are still creatures of faith.

**Notes**

1. Philosopher Immanuel Kant (1724–1804) introduced his theory of 'Categorical Imperative' in Groundwork of the Metaphysics of Morals, 1785.

2. Jordan B. Peterson, Maps of Meaning: The Architecture of Belief, New York and London 1999, p.29.

3. See Ernst Jentsch, 'On the Psychology of the Uncanny', 1906; Sigmund Freud, 'The Uncanny', 1919; Julia Kristeva, Powers of Horror: An Essay on Abjection, New York 1982; Masahiro Mori, 'The Uncanny Valley', Energy, 1970, vol .7, no. 4, pp.33–35.

4. Sir Winston Churchill cited by Lisa Jardine, Homage to Highbury, BBC News Magazine, 15 May 2006, http://news.bbc.co.uk/1/hi/magazine/4766707.stm, accessed 14 March 2017. See also Lisa Jardine, On a Grander Scale: The Outstanding Life of Sir Christopher Wren, New York 2003.

5. Hal Foster, Recodings: Art, Spectacle, Cultural Politics, Seattle 1985, p.201. See also Dick Hebdige, Subculture: The Meaning of Style, London and New York 1979.

6. Writers and theorists associated with defining Postmodernism include Jean Baudrillard, Julia Kristeva, Michel Foucault, Dick Hebdige, Fredric Jameson, Jean-François Lyotard, and the artist Victor Burgin.

7. Tom Turner, City as Landscape: A Post-postmodern View of Design and Planning, London 1996; Mikhail Epstein, Russian Postmodernism: New Perspectives on Late Soviet and Post-Soviet Literature, New York and Oxford 1999; Alan Kirby, Digimodernism: How New Technologies Dismantle the Postmodern and Reconfigure Our Culture, New York and London 2009; Raoul Eschelman, Performatism, or the End of Postmodernism, Aurora 2008; Nicolas Bourriaud, Altermodern, London 2009; Timotheus Vermeulen and Robin van den Akker, 'Notes on Metamodernism', Journal of Aesthetics and Culture 2010, vol. 2, pp.1–13.

8. Peterson 1999, pp.138 and 191.

9. Prime Minister Theresa May, Keynote Speech, Conservative Party Conference, 4 October 2016, http://press.conservatives.com/, accessed 14 March 2017.

10. Nathan Coley, A Place Beyond Belief, 2012, illuminated text on scaffolding.

11. Peterson 1999, p.222.

Published by the Trustees of the National Galleries of Scotland to accompany the presentation of Nathan Coley's work in the exhibition NOW, held at the Scottish National Gallery of Modern Art, Edinburgh from 25 March to 24 September 2017.

ISBN 978-1-911054-13-9

Designed and typeset in Zimmer by Matt Watkins
Printed on Condat Mat Perigord by Wonderful Books, Eindhoven

This exhibition has been assisted by the Scottish Government and the Government Indemnity Scheme.

This catalogue has been made possible thanks to kind assistance from Parafin, London.

NOW is generously supported by Kent and Vicki Logan, Walter Scott and Partners Limited, NGS Foundation, Robert and Nicky Wilson, and other donors who wish to remain anonymous.

The proceeds from the sale of this book go towards supporting the National Galleries of Scotland. For a complete list of current publications, please write to National Galleries of Scotland Publications, Bridge Lodge, 70 Belford Road, Edinburgh EH4 3DE or visit our website www.nationalgalleries.org

National Galleries of Scotland is a charity registered in Scotland (no. SC003728)

Plates and details:
All works by Nathan Coley
The Lamp of Sacrifice, 286 Places of Worship, Edinburgh 2004, 2004, pp.6-7, 22, 24-25, 27, 28-29, 40, 44.
Paul, 2015, pp.3, 13, 14-15, 16, 17, 18-19, 21.
Tate Modern on Fire, 2017, pp.9, 31, 32-33, 34-35, 37, 38-39.

All photography by Graeme Yule
© National Galleries of Scotland
All artworks © the artist

NATIONAL
GALLERIES
SCOTLAND